BEVERLEY

HISTORY TOUR

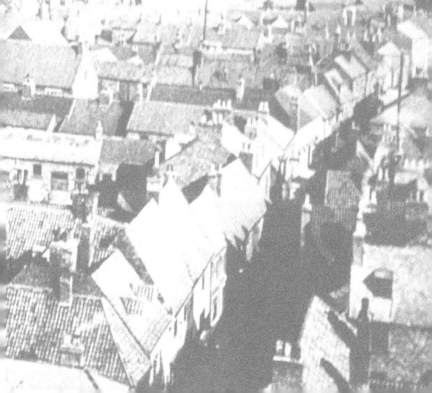

Map contains Ordnance Survey data © Crown Copyright and database right [2015]

First published 2015

Amberley Publishing
The Hill, Stroud,
Gloucestershire, GL5 4EP
www.amberley-books.com

Copyright © Margaret Sumner &
Patricia Dean, 2015

The right of Margaret Sumner &
Patricia Dean to be identified as the
Authors of this work has been asserted
in accordance with the Copyrights,
Designs and Patents Act 1988.

ISBN 978 1 4456 4860 6 (print)
ISBN 978 1 4456 4861 3 (ebook)

British Library Cataloguing in
Publication Data.
A catalogue record for this book is
available from the British Library.

Typesetting by Amberley Publishing.
Printed in Great Britain.

INTRODUCTION

Beverley is situated on the spring line at the foot of the Yorkshire Wolds, above the floodplain of the River Hull. Iron Age barrows discovered on Westwood show early settlers favoured the higher ground, but modern Beverley grew up around a monastery founded by John, successively bishop of Hexham and York, early in the eighth century.

By 1086, Beverley was a prosperous settlement. John's cult and shrine continued to grow in popularity as a centre of pilgrimage, particularly after his canonisation in 1037, and his monastery, or mynster – a college of secular priests with substantial estates and privileges – served as a religious centre for the surrounding area. The main source of Beverley's wealth lay in the wool trade, evidenced by modern street names such as Walkergate, Dyer Lane and Flemingate. Local wool and cloth was exported via Beverley Beck and the River Hull, while the town's annual five-day fair attracted merchants from near and far, including the Low Countries. The original market area may well have encompassed Wednesday Market, Highgate and Eastgate. A second marketplace was later added to the north-west, while close by a chapel dedicated to St Mary served the growing population at that end of town.

The rights to the common pastures which have helped to define Beverley's development also date from this period. In 1258, the Archbishop of York permitted townsmen to pasture their animals on Westwood, Swinemoor and Figham in return for their agreement

not to build upon these open spaces. All three remain common land; Westwood, in particular, has played a vital role in protecting Beverley from overbuilding and ensuring that the area west and north of the town centre remains its 'fairest part'. In the eighteenth century the town became home to the Quarter Sessions and a popular social centre for local gentry families. The season revolved around the theatre, concerts, races and assemblies.

Notable public buildings such as the guildhall, market cross and assembly rooms were built and Newbegin and North Bar became home to fashionable Georgian residences.

By the early nineteenth century Beverley had entered a period of decline. The town was little more than a local market centre, eclipsed in importance by Hull. However, the coming of the railway in 1846 heralded a change in its fortunes. Tanning, shipbuilding, iron founding and light engineering all made their mark. Since their demise, Beverley has become increasingly reliant on its role as an administrative centre for the wider area – as home to East Riding County Council (1889–1974), Humberside County Council (1974–96), Beverley Borough Council (1974–96) and currently East Riding of Yorkshire Council – and as an attractive place to live for commuters to Hull, York and Leeds. Beverley does not stand still. Modern developments over the last thirty years have seen the town expand rapidly, particularly to the north-east and south-west. Development on the former Hodgson's Tannery site, close to the minster, will soon be complete; with a college, hotel, cinema, shops and housing it implies a radical reorientation of the town.

ACKNOWLEDGEMENTS

Pat Dean has built up her collection over a long period and wishes to acknowledge her debt to all those who, over the years, have given copies of illustrations from their own collections. In the absence of a catalogue with details of provenance, it is impossible to thank by name all those who have contributed to this book, but the gratitude of the author is nonetheless sincere. Margaret Sumner wishes to thank her husband, Ian, for all his help in photographing Beverley and in researching the captions. She also wishes to acknowledge the work of the many authors — published and unpublished — who have done so much to expand our knowledge and understanding of the town.

BEVERLEY

1. SATURDAY MARKET, *c.* 1860

The recently refurbished Market Cross (a fine centrepiece for today's Christmas illuminations) dates from 1711–14. The board (*far left*) advertises the extensive range of teas offered by George Hobson, grocer. The adjoining shop was rebuilt around 1863 by William Hawe, and Hobson traded here on the corner of Old Waste until 1906. Since then it has been a bank – first Midland, now HSBC. At No.1 Saturday Market the name of Beilby's saddler's lives on – clearly visible on the wall of the modern estate agency.

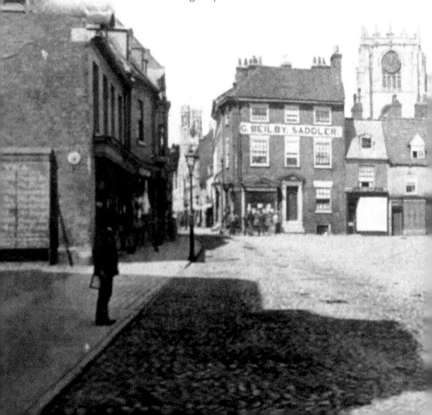

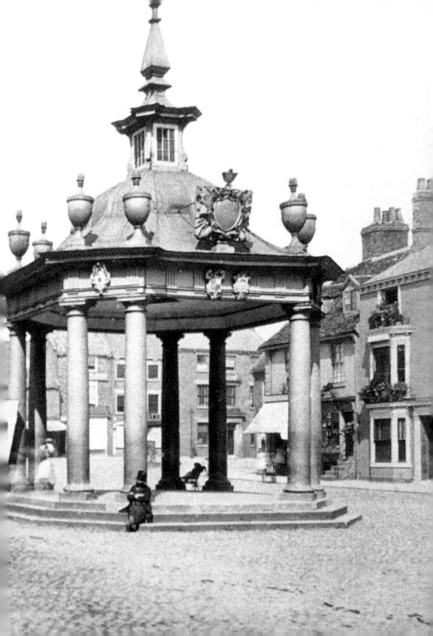

2. SATURDAY MARKET, *c.* 1910

A Saturday market has certainly been held in Beverley since 1293 and the marketplace – perhaps then extending as far as Hengate and Ladygate – may have been laid out a century earlier. The Edwardian market is much smaller than its modern equivalent. Opposite Butterdings, where stalls crowd together today, carriers' carts stand ready for loading and unloading. Meanwhile a charabanc passes by, full of men smartly dressed in mufflers – perhaps on their way to the races?

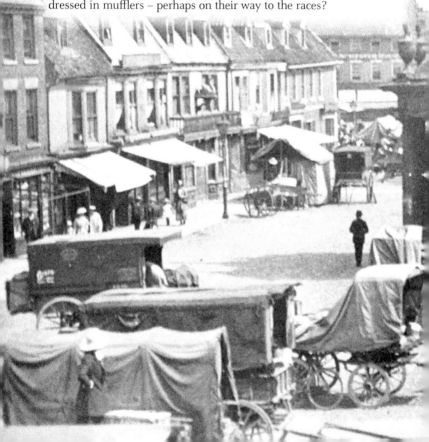

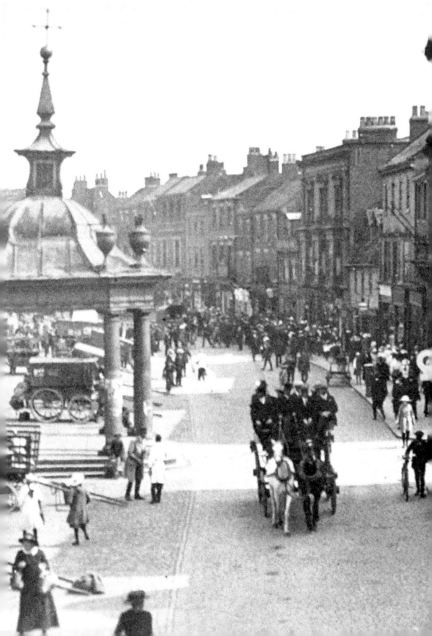

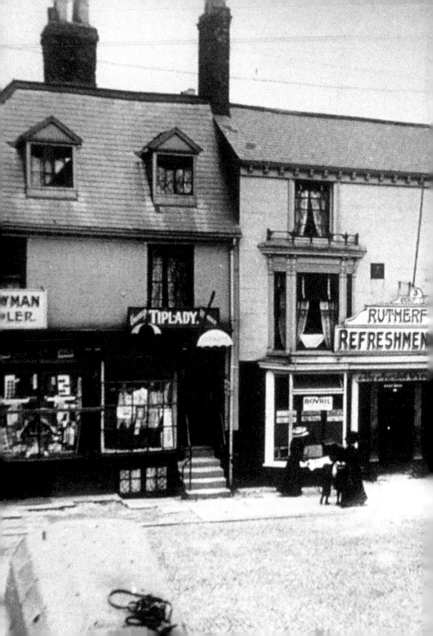

3. BUTTERDINGS, *c.* 1905

Certain areas of Saturday Market were devoted to particular goods, among them Sow Hill, Butterdings and Corn Hill. Butterdings was formerly the site of the medieval hall of the Archbishop of York – a stone building known as the Dings. Akrill's gunmakers occupies one of a row of shops built in the 1750s. It opened in 1833 and remained in family ownership until it closed in 2001. A succession of cafés has recently occupied the premises, but the winged-wheel CTC (Cyclists' Touring Club) emblem still retains its place above the door.

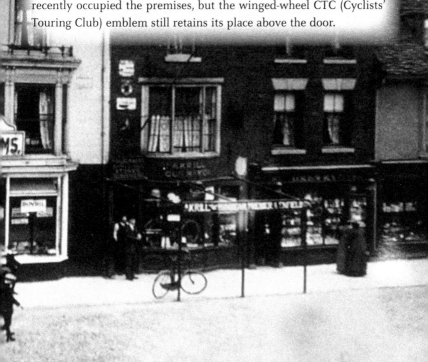

4. CORN EXCHANGE, c. 1880

Beverley's first corn exchange was created in 1825 from part of the butchers' shambles (1753). It was demolished and a new exchange built on the same site in 1886. In 1911 Ernest Symmons opened Beverley's first cinema here, using his own generator (mains electricity only arriving in town in 1930). Until trading ceased in 1947 the Picture Playhouse operated alongside the exchange, leaving the audience sometimes picking grain off their seats! After a spell as a bingo hall it reopened as Beverley's – by then only – cinema in 1982, before closing permanently in 2003. The refurbished building is now Brown's Department Store.

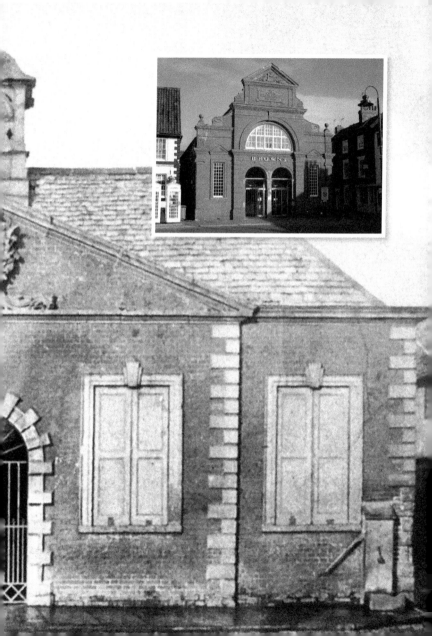

5. TOLL GAVEL, *c.* 1910

Before pedestrianisation, Toll Gavel was the main road to Hull and Hessle. The hanging sign of the Golden Ball (*front right*) marks the prominent Beverley pub and brewery, run by the Stephenson family until its sale to Hull Brewery in 1919. On the left is another pub – the Litchfield Hotel. Formerly known as the Red Lion, it was bought and renamed in the 1890s by prominent Beverley publican Robert Attwood Litchfield. The Litchfield closed in 1972 and is now the Halifax.

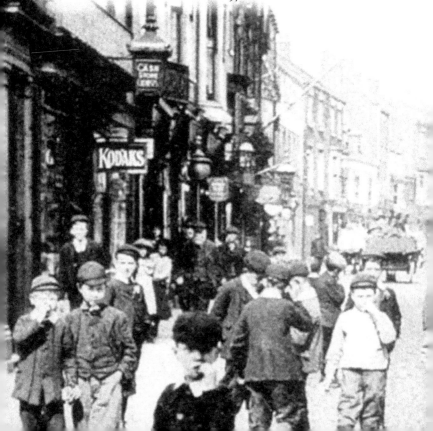

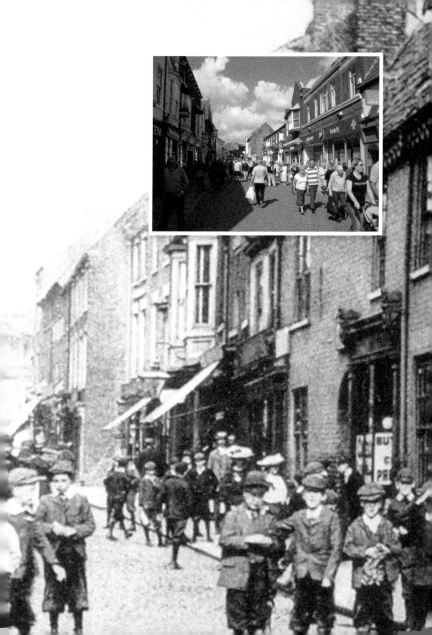

6. CROSS STREET/TOLL GAVEL, *c.* 1950

The Golden Ball closed in 1924 and Woolworths traded here from around 1930 until 2009, when the store reopened as Boots. On the left is the Co-op (now Wilkinson). Beverley's Cooperative Society first opened at Nos 25–31 Eastgate before the First World War, with other shops following in Toll Gavel, Wednesday Market and Grovehill Road. It merged with the larger Hull Society in 1929 and opened here shortly afterwards. A branch of the Maypole Dairy Co. once stood north of the Toll Gavel and Landress Lane junction. Founded in Wolverhampton in 1887, the Maypole chain grew rapidly. It mainly traded in butter, margarine, eggs, tea and condensed milk – much of it imported from Denmark. By 1915 there were 985 Maypole stores including the Beverley branch, which opened here between 1905 and 1913.

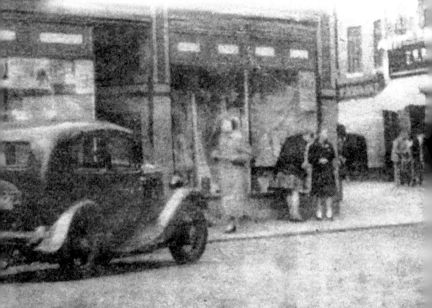

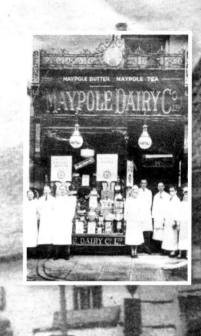

7. LOWER TOLL GAVEL, *c.* 1900

Hanging lamps mark the shop of Uriah Butters, draper and enthusiastic local photographer. The house of Anne Routh, a notable benefactor of the town, was built in 1703 and is now a café. Its red-framed display boards are set in recessed panels, which mark window openings blocked to save window tax. Bon Marché occupies the site of the old Oddfellows Hall. The Independent Order of Oddfellows was a friendly society with a number of lodges in nineteenth-century Beverley.

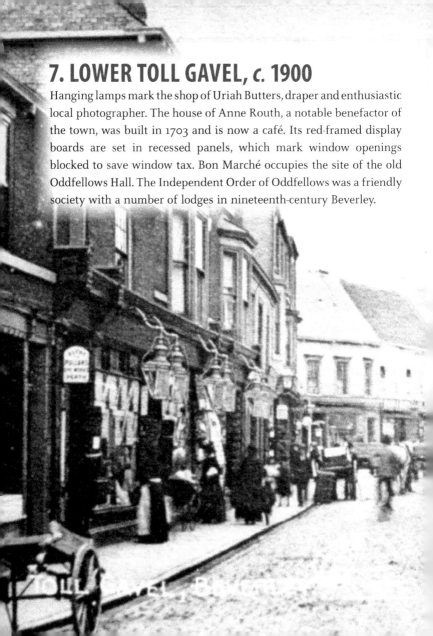

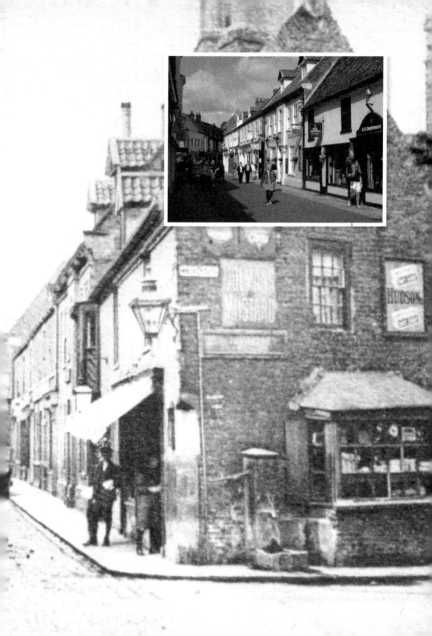

8. WALKERGATE, 24 JULY 1912

A cart makes its way through flash floods caused when the culverted Walker Beck, which ran along Walkergate, overflowed after a cloudburst. On the corner is the shop of James Horner – tobacconist and dealer in glass and china. This was for many years Lightowler's painters and decorators and is now a branch of Boots. Next door was the yard of George Pape – plumber, joiner and glazier. Then came the flourishing business of William Dixon, Complete House Furnisher & Cycle Agent.

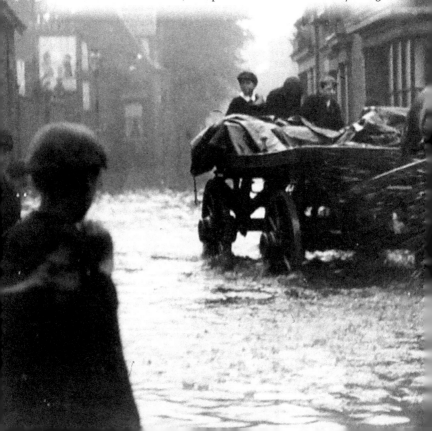

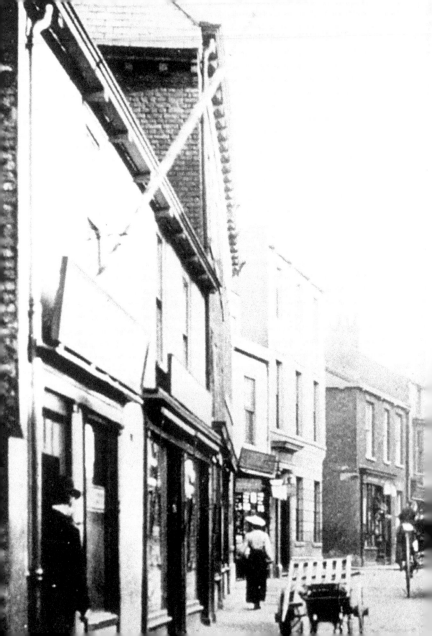

9. BUTCHER ROW, *c.* 1905

In 1899 William Dixon was trading at No.5 (now Body Shop). By 1905, he had acquired the adjoining premises (now Cooplands) and by 1912 hairdresser David Robson's – marked here by the striped pole. In the mid-nineteenth century, under landlord Daniel Boyes, the Angel was a centre of Liberal politics in the town. Next door to the inn is Charles Mitchell – tobacconist and sports goods dealer. Across the street is the elaborately painted shop of Robert Campey, decorator. Established in Beverley since 1834, Campey's had recently moved from Well Lane.

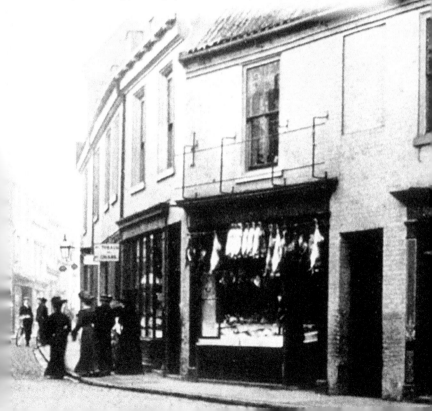

10. MARBLE ARCH

Known to some Beverlonians as the 'Marble Itch', the Marble Arch took its name from a local landmark – a passage off Butcher Row that ran between the earlier cottages and shops. Unlike the rival Picture Playhouse, the Marble Arch was a purpose-built cinema. Opened in 1916 under the management of Edward Butt, it could seat 1,100 people and also boasted a café. However, by 1961 the cinema, like its competitors, was turning to bingo and it showed its last film in 1964. It closed in 1967 to be demolished and replaced by a succession of supermarkets – most recently Marks & Spencer Simply Food.

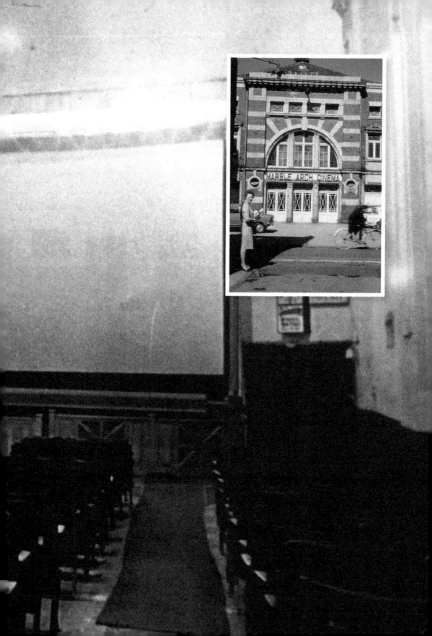

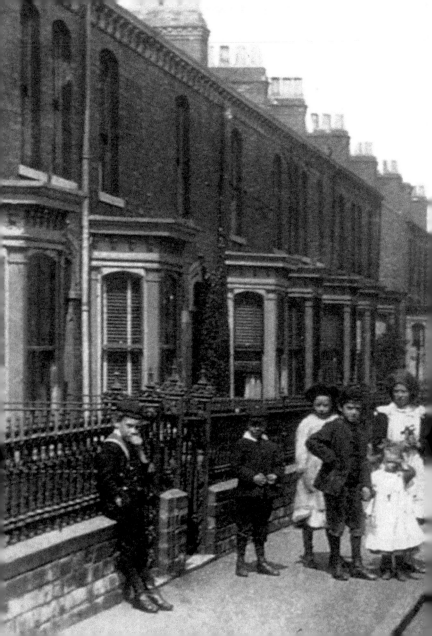

11. WILBERT LANE, c. 1900

Dating back to the 1860s, the Moulders Arms (off right) commemorates the industrial past of this area. Warehouses (*rear right*) mark the site of the original Crosskill Ironworks, founded around 1827 by the son of a Beverley whitesmith. By the 1850s over 800 men were employed in works extending on both sides of Wilbert Lane. The original business was sold in 1864 (eventually closing in 1879), but that same year Crosskill's sons set up a new enterprise – William Crosskill & Sons – in Eastgate.

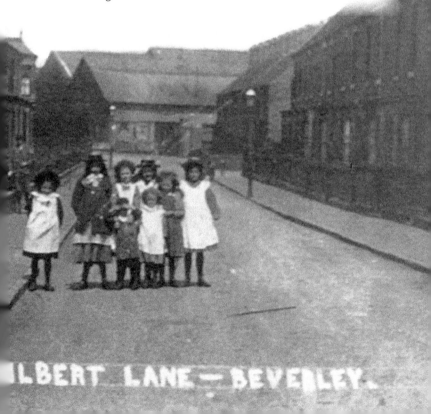

ILBERT LANE — BEVERLEY.

12. BEVERLEY STATION, *c.* 1970

The railway came to Beverley in 1846 when George Hudson's York & North Midland Railway opened its Hull–Bridlington line. A line to York followed in 1865, but closed a century later. G. T. Andrews' station building underwent some changes over the years. A canopy was added over the entrance, while orange North Eastern Region signs appeared in the days of British Railways. In 1993 the station was restored to something like its original appearance. The two wings now house Cerutti's restaurant and delicatessen.

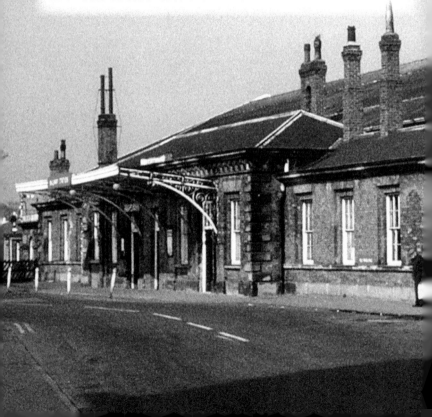

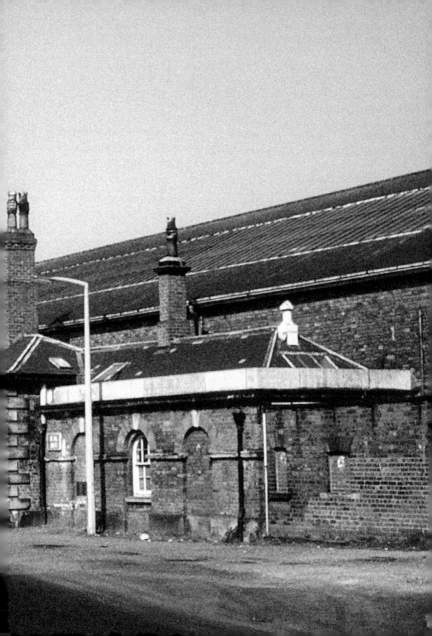

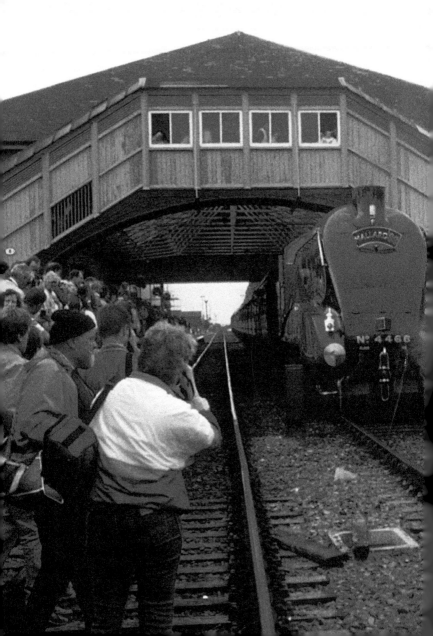

13. BEVERLEY STATION, JULY 1988 AND c.1960

Steam traction ended on the Beverley line in the 1960s, but specials still came through. *Mallard*, a class A4 Pacific, remains the holder of the speed record for steam locomotives – 125.88 mph (202.58 km/h), achieved south of Grantham on 3 July 1938. Here enthusiasts flock to see the newly restored locomotive and celebrate the fiftieth anniversary of its record-breaking run. Beverley had a small garden assiduously cultivated by its staff. The gardens, which lay between the station and the signal box, are long gone. However, they have been replaced to some extent by the floral displays, which have brightened Station Square since it was paved (and given a clock) in 1990.

14. WEDNESDAY MARKET, *c.* 1870

Wednesday Market – once the medieval fish market – fell into disuse during the eighteenth century and remained a market in name only until stalls were reintroduced in 1984. The obelisk was built in 1762/63 to replace a market cross erected earlier in the century and was removed in 1881. Highgate House lost its two southern bays in 1909 to make way for Lord Roberts Road. The Primitive Methodist chapel (*c.* 1868), with capacity for 700 worshippers, was demolished in 1955 to make way first for Crystal Motors and in 1994 for the present Boyes department store.

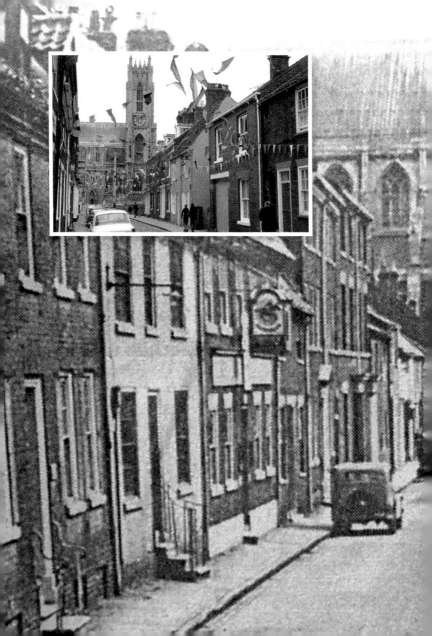

15. HIGHGATE, *c. 1920*

Also known as Londoners' Street after the London merchants attending the annual Cross fair, Highgate was originally part of the 'high street' running from the minster to North Bar. The George and Dragon (more recently the Monk's Walk) has been a pub since at least 1802. Its Georgian exterior hides a medieval hall. Two doors down is a house that once belonged to Col Oliver de Lancey – member of a powerful New York family and a loyalist during the American War of Independence. He died in Beverley in 1785 and is buried in the minster. Delancey Street, the main thoroughfare of Manhattan's Lower East Side, commemorates the family. The inset image of Highgate is seen decorated for another celebration – the Queen's Silver Jubilee in 1977.

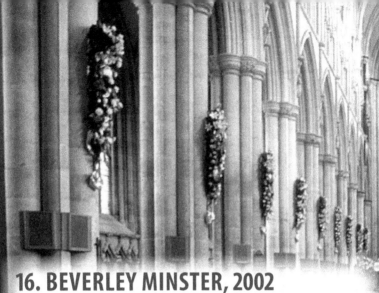

16. BEVERLEY MINSTER, 2002

The magnificent nave of Beverley minster is seen here decorated for the Queen's Golden Jubilee service. The minster was rebuilt after the collapse of the central tower in 1213. The fourteenth-century nave blends harmoniously with the earlier east end and crossing. The original trussed rafter roof of the nave survives. Oaks from Bishop Burton and elsewhere were given in 1388 and an indulgence to fund 'new work' promoted in 1408. A treadwheel – operated here by architectural historian Ivan Hall – is situated in the roof of the minster above the central crossing. The wheel raises a decorative boss in the vault, so creating an opening that allows building materials to be winched up into the roof space. It was installed in the early eighteenth century to facilitate a major restoration programme, overseen by Nicholas Hawksmoor and undertaken by William Thornton of York, which did much to protect the fabric of the church. The minster now offers a regular programme of roof tours to its visitors – Monday–Saturday at 11.15 a.m. and 2.15 p.m.

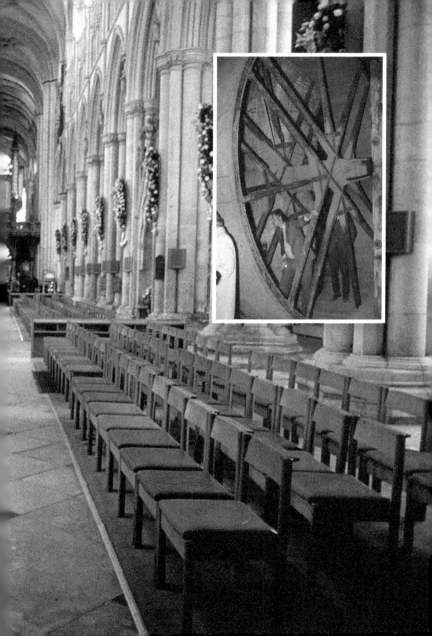

17. EASTGATE, *c.* 1900

The Victorian extension to the minster vicarage (*near left*) was demolished along with the three adjoining cottages for road widening in the early 1960s. Grocer Richard Care (*opposite*) seems to have the decorators in – perhaps from his neighbours Moody & Sons (the last dormered house on the left). Care – three times mayor of Beverley – also had a larger shop in Saturday Market. Hidden by the bend in the road is the Eastgate site of William Crosskill & Sons.

EASTGATE — BE

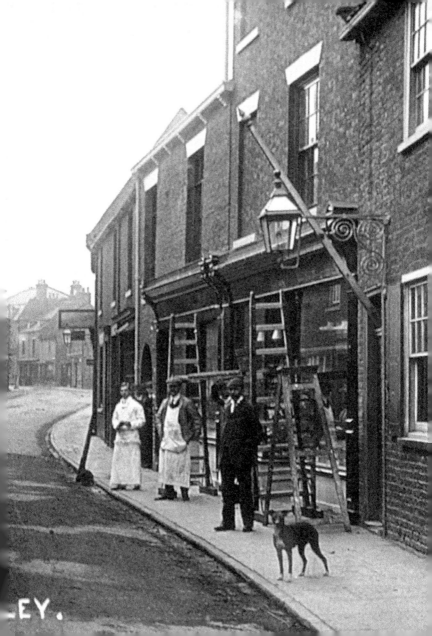

EY.

18. BEVERLEY FRIARY, 2009

By 1960 Beverley's thirteenth-century Dominican friary, a rare survivor among medieval friary buildings, was in a poor state of repair. Long subdivided into three separate dwellings, it had been surrounded by industry for almost a century – first by Crosskill's and later by the works of Beverley inventor and industrialist Gordon Armstrong. After making 4½-inch Howitzer shells during the First World War, Armstrong returned to manufacturing automotive components, including his patented shock absorber, and moved his main works here from the North Bar Within in 1919. Armstrong's decision to purchase the friary for demolition triggered a prolonged campaign to save it. Restoration work was completed in 1974 and ten years later the friary opened as a youth hostel. The present building is just fragment of a much larger complex. Most of the church, for example, now lies beneath the railway line.

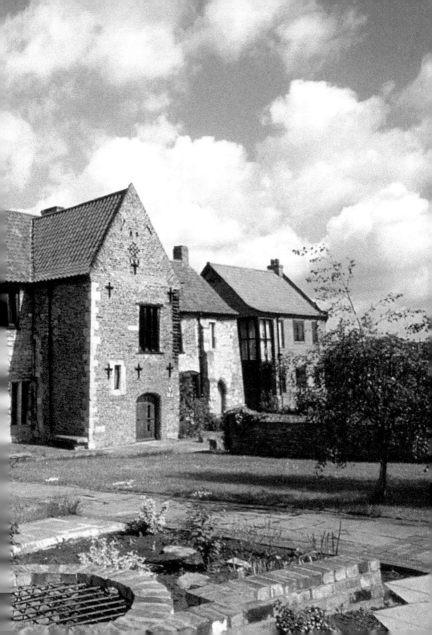

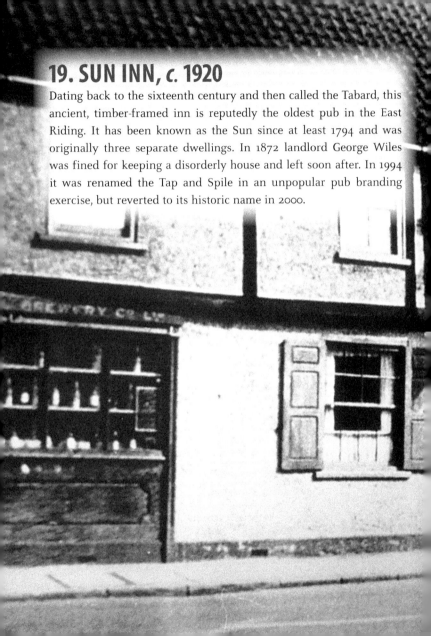

19. SUN INN, *c.* 1920

Dating back to the sixteenth century and then called the Tabard, this ancient, timber-framed inn is reputedly the oldest pub in the East Riding. It has been known as the Sun since at least 1794 and was originally three separate dwellings. In 1872 landlord George Wiles was fined for keeping a disorderly house and left soon after. In 1994 it was renamed the Tap and Spile in an unpopular pub branding exercise, but reverted to its historic name in 2000.

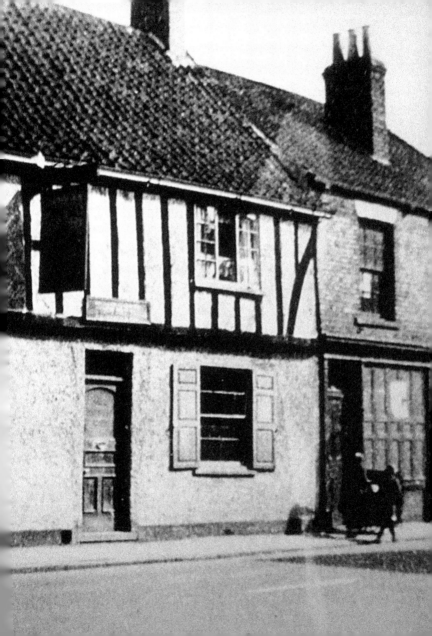

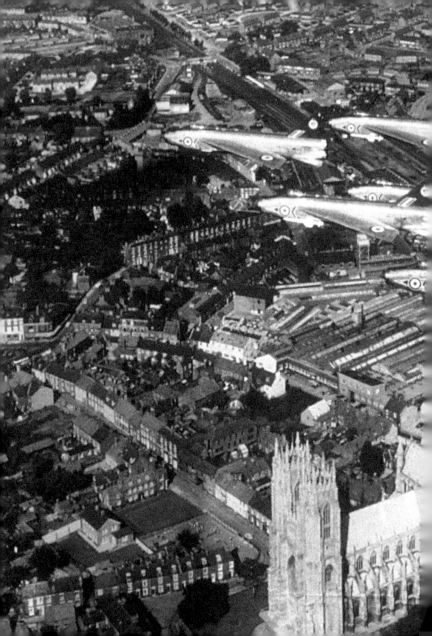

20. FLEMINGATE, 1952

Lightning F2s of 92 Squadron take part in a farewell fly-past before leaving RAF Leconfield for Germany; in April 2015 the RAF will end its seventy-nine-year association with the former bomber base, withdrawing the Air Sea Rescue helicopters that have maintained its presence there in recent years. Behind the minster is Armstrong's Patents and far right is Hodgson's Tannery. Several tanneries once operated on the southern edge of Beverley and Hodgson's (founded in 1812) came to predominate. On its closure in 1978, the site was divided between a chemical works and the new Museum of Army Transport. By 2009 everything has gone, clearing the way for a major redevelopment including the new Beverley campus of East Riding College, a cinema, hotel, shops and housing.

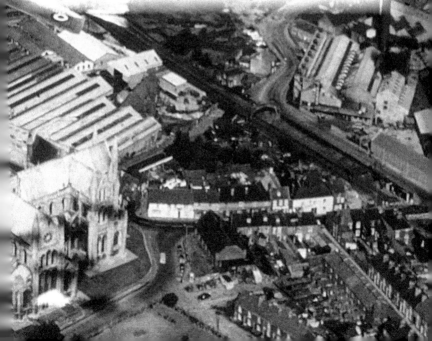

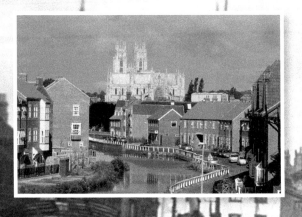

21. BEVERLEY BECK, *c.* 1900

Humber keels gather alongside Barker's Linseed Mill. The Beck is slightly wider here so vessels could turn. The single-masted, square-rigged keels were the workhorse of the Humber basin for over 500 years. Seed crushing produced linseed oil, used to make putty by mixing it with whiting (crushed chalk) from Westwood. Later Barker & Lee Smith, the mill was converted to animal feed production in 1952 and demolished in 2000 for the Barker's Wharf housing development.

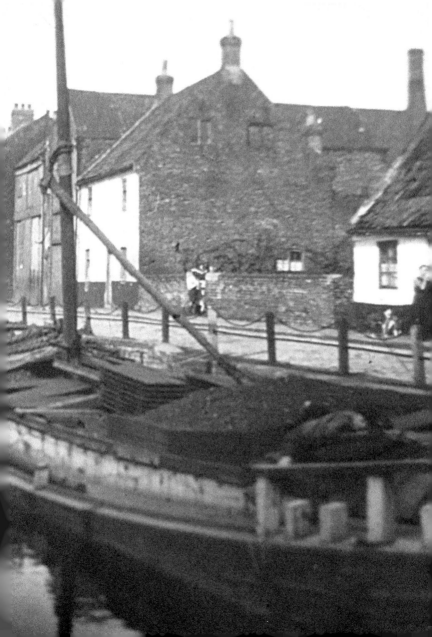

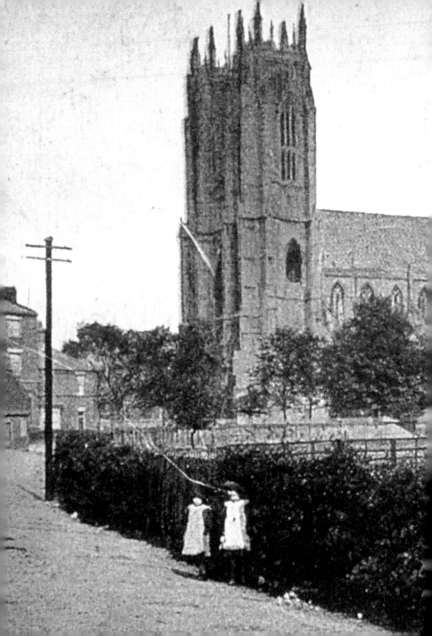

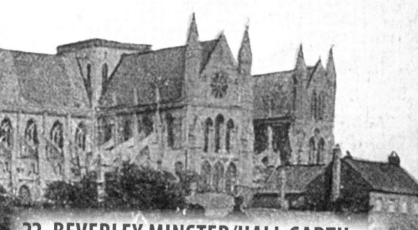

22. BEVERLEY MINSTER/HALL GARTH,
c. 1900

The archbishops left the Dings in the thirteenth century – transferring ownership to the town – and moved to the moated Hall Garth site south of the minster. By the 1820s some of the surviving buildings had become the Hall Garth Inn (or Admiral Duncan). Having a pub this close to his church so upset long-serving vicar Canon Nolloth that, in 1896, he bought it and closed it down. The Hall Garth became a farmhouse and was eventually demolished in 1958.

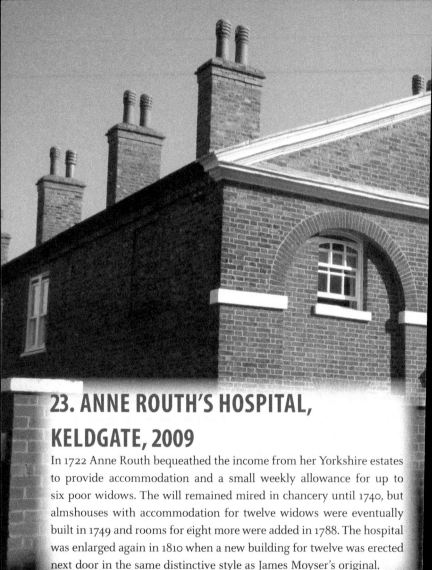

23. ANNE ROUTH'S HOSPITAL, KELDGATE, 2009

In 1722 Anne Routh bequeathed the income from her Yorkshire estates to provide accommodation and a small weekly allowance for up to six poor widows. The will remained mired in chancery until 1740, but almshouses with accommodation for twelve widows were eventually built in 1749 and rooms for eight more were added in 1788. The hospital was enlarged again in 1810 when a new building for twelve was erected next door in the same distinctive style as James Moyser's original.

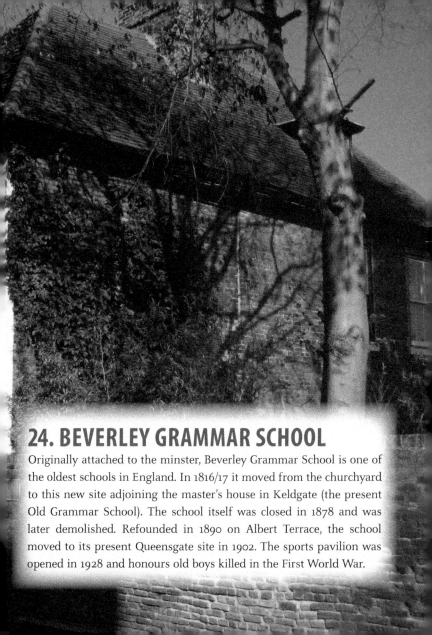

24. BEVERLEY GRAMMAR SCHOOL

Originally attached to the minster, Beverley Grammar School is one of the oldest schools in England. In 1816/17 it moved from the churchyard to this new site adjoining the master's house in Keldgate (the present Old Grammar School). The school itself was closed in 1878 and was later demolished. Refounded in 1890 on Albert Terrace, the school moved to its present Queensgate site in 1902. The sports pavilion was opened in 1928 and honours old boys killed in the First World War.

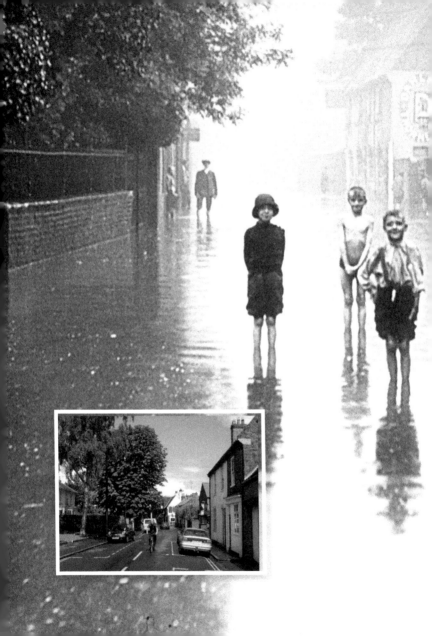

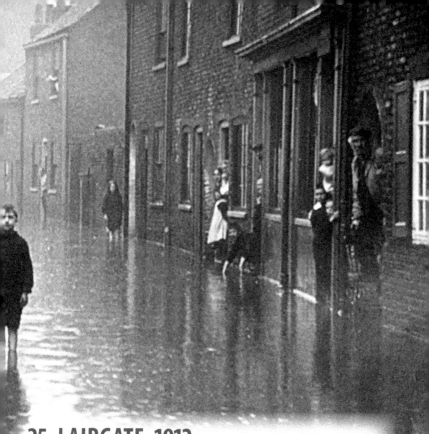

25. LAIRGATE, 1912

Lairgate was also badly affected by the flash flood of July 1912. In the distance is the Tiger (another eighteenth-century inn), originally known as the Black Bull. In the 1820s the inn had its own brewhouse, but by 1912 it was serving ales from Darley's Thorne Brewery. It had been renamed following the closure of the Tiger Inn on North Bar Within in 1847 and was refurbished in 1931. Many of the cottages seen here have since been replaced by modern developments.

26. KELDGATE, *c.* 1906

Fife and drums precede men of the East Yorkshire Regiment as they march into town. They are passing the wall of Lairgate Hall, the eighteenth-century home of the Pennyman family, whose kitchen gardens (complete with hothouse) occupied this corner of the extensive grounds. Beverley Corporation purchased the hall in 1926, building Admiral Walker Road and developing the grounds as council housing. The hall itself was used by local government until 1996 and is now an office complex. Once a popular residential street with several fine houses, Keldgate was also home to a tannery until 1986. Run latterly by Melrose Tanners, part of the site is now a housing development – Melrose Park.

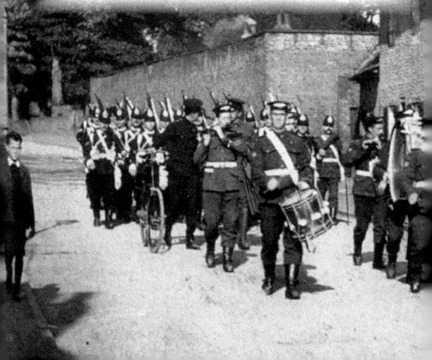

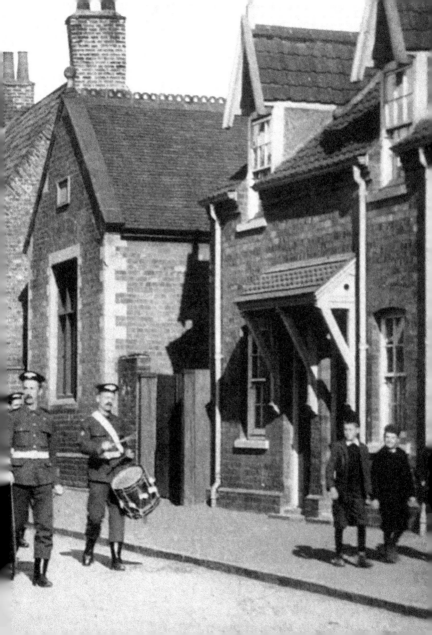

27. THE OLD FIRE STATION, ALBERT TERRACE, c. 1907

The Beverley (C) Company, 2nd Volunteer Battalion, East Yorkshire Regiment pose outside their headquarters – a health centre since 1987. First opened in 1861 as the Foundation or Middle Class School, the Grammar School briefly found a home here after it was refounded in 1890. When that school moved to Queensgate in 1902 the building became a drill hall. In 1950 it was taken over by East Riding Fire Brigade, remaining as Beverley's fire station until the move to New Walkergate in 1983.

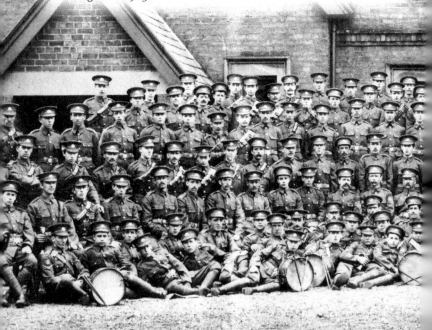

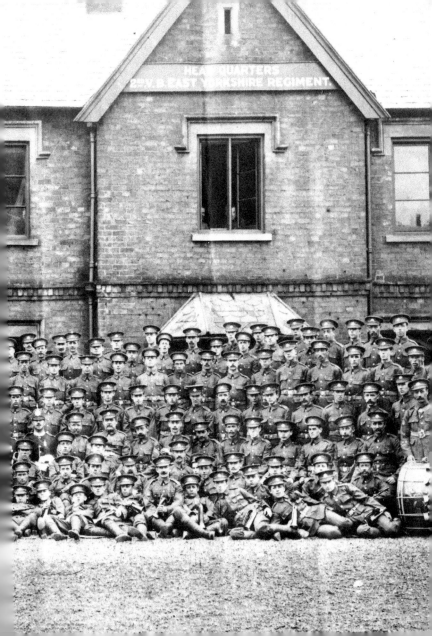

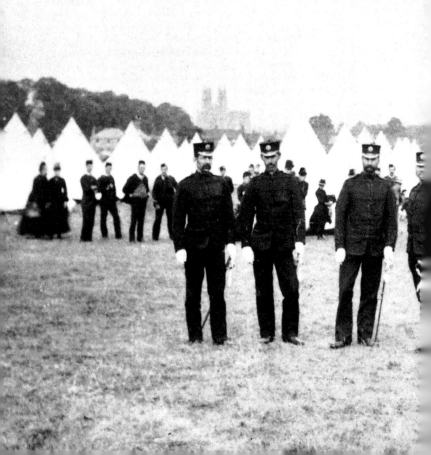

28. WESTWOOD, 1887

The 2nd Volunteer Battalion is in camp close to the Union Mill (or anti-mill), once one of five mills on Westwood. Built in 1799 by the Union Mill Society, the mill operated as a cooperative, in competition with private owners accused of overcharging. The upper part of the tower was eventually dismantled, and in 1896 the base became (and remains part of) the clubhouse of Beverley and East Riding Golf Club.

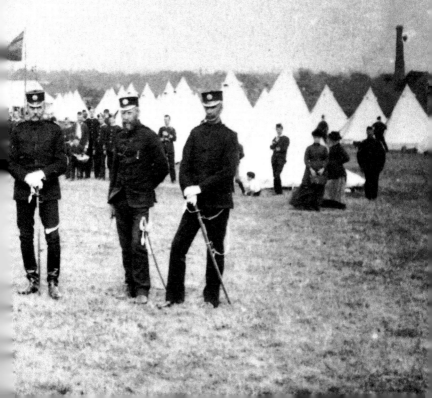

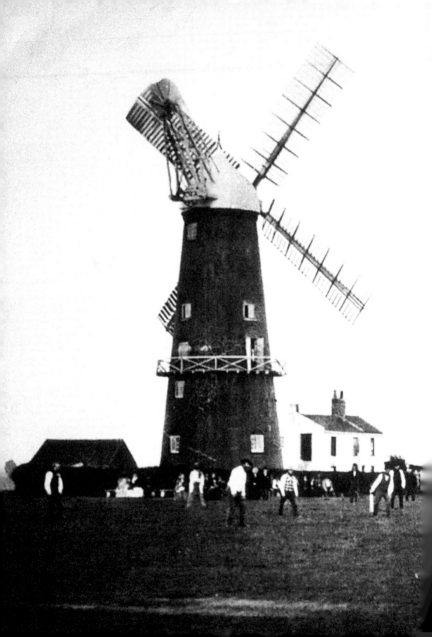

29. BLACK MILL, WESTWOOD, *c.* 1860

Formed in 1889, the golf club was previously based at the Black Mill. Cricket was also played here regularly between 1825 and 1909, when the Norwood Park recreation ground was opened. A mill has stood here since the 1650s, but the present structure (also known as Far, High or Baitson's Mill) was rebuilt by Gilbert Baitson in 1803 on a sixty-five-year lease. After damage by fire, its working gear was removed by the pasture masters when the lease expired in 1868.

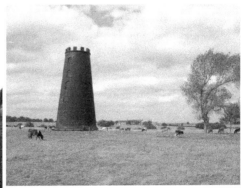

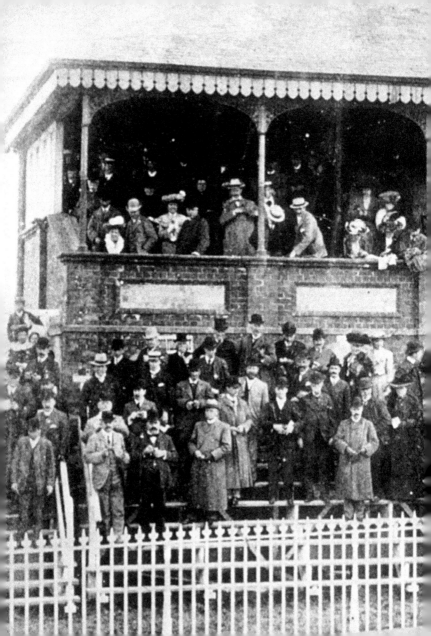

30. BEVERLEY RACECOURSE, 1903

The cup so prominently displayed here is the 1903 Watt Memorial Plate. The race was first held in 1885 and was won on this occasion by Mr Reid's racehorse, Cliftonhall. Organised races have been held on Westwood and Hurn for over 300 years. Stands followed somewhat later – the first in 1767 and a second (seen here) in 1887. Both were demolished in 1928.

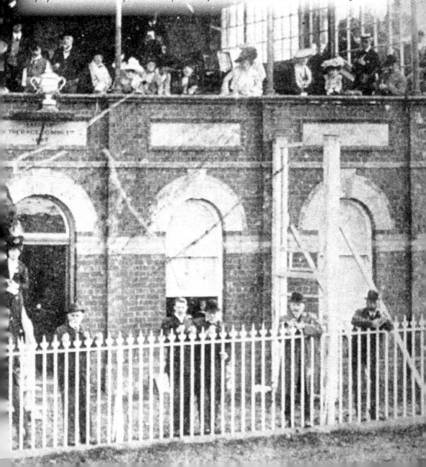

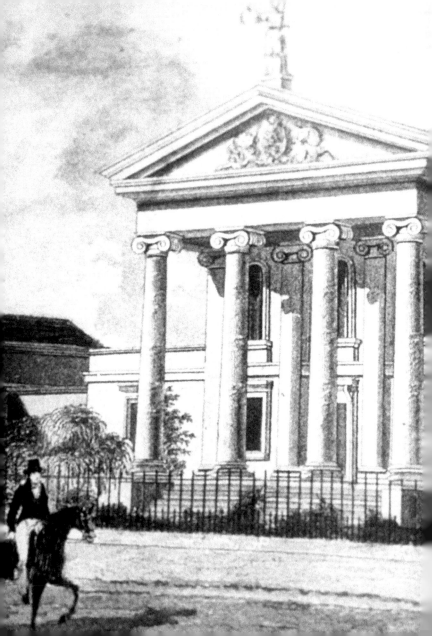

31. EAST RIDING SESSIONS HOUSE

Built 1805–10, the sessions house incorporated a court with a prison to the rear. By 1835 the prison had 126 cells, but forty years later its inmate population averaged only half that number. Inside, the courtroom retained many of its original features and fittings until its closure in 2002 with the opening of the new magistrates' court in Lord Roberts Road. The main building has now been converted into a health spa; the southern wing accommodates a restaurant and the northern wing Beverley Police Station.

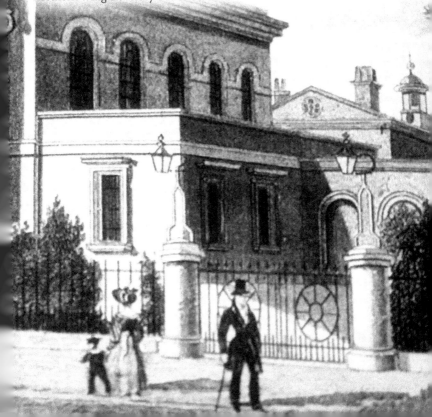

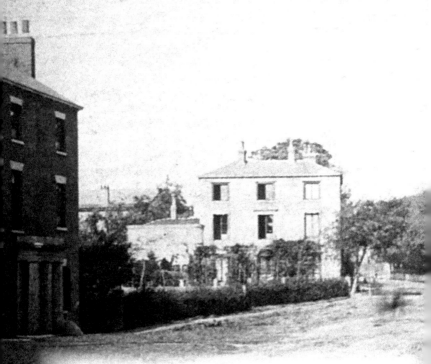

32. NEW WALK, *c.* 1870

New Walk was first laid out by Beverley Corporation in the 1780s as a shady promenade for ladies and gentlemen. The regular lines of chestnut trees replaced more varied and irregular plantings in 1822, while most of the houses are late Victorian. For some years, New Walk has provided a picturesque finish for the East Yorkshire Classic road race.

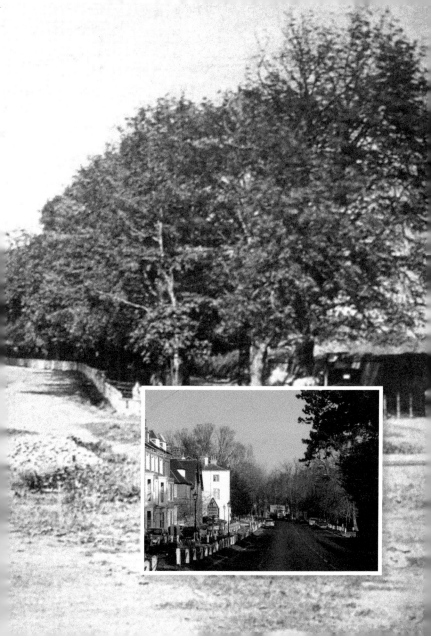

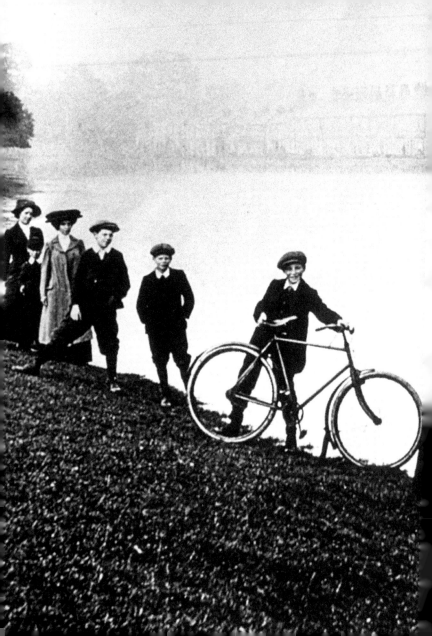

33. WILLOW GROVE, 24 JULY 1912 AND 25 JUNE 2007

In 1912 a cloudburst saw nearly 2 inches of rainfall in ninety minutes, and the old riverbed in Newbald Road became a 'raging torrent', collecting in the low ground at the end of Willow Grove. The summer of 2007 was the wettest since then. On 25 June one-sixth of the area's annual rainfall was recorded in less than twelve hours. Houses in Willow Grove were among those flooded and the land before them once again became a lake. A £1 million scheme of flood defence work now protects these properties.

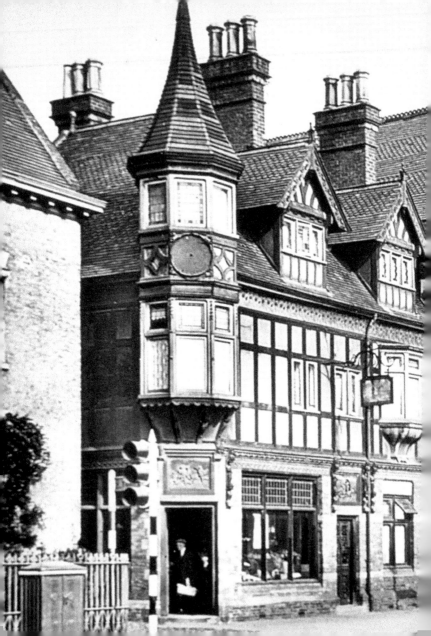

34. NORTH BAR WITHOUT, *c.* 1930

North Bar Chambers, Amphion House (No. 2 North Bar Without), and the first footpath under the bar were built in 1793/94 on the site of the early fifteenth-century St Mary's Hospital, which was by then in ruinous condition. A century later the adjoining property was the house and shop of woodcarver James Elwell, who remodelled it on a lavish scale with carved figures, heraldic shields and cartoon scenes featuring Disraeli and Gladstone. Far left stands Wylies House, demolished in 1960 for the construction of Wylies Road.

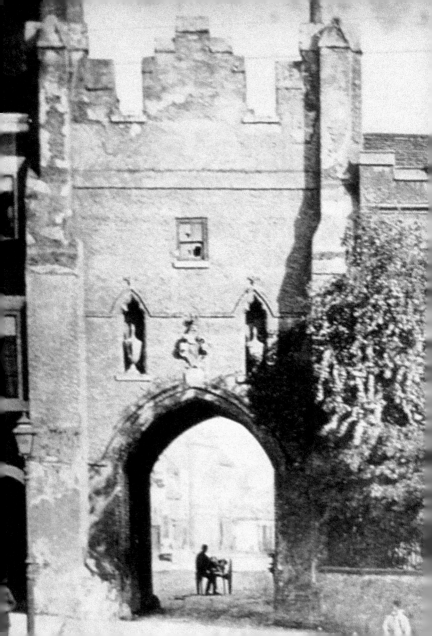

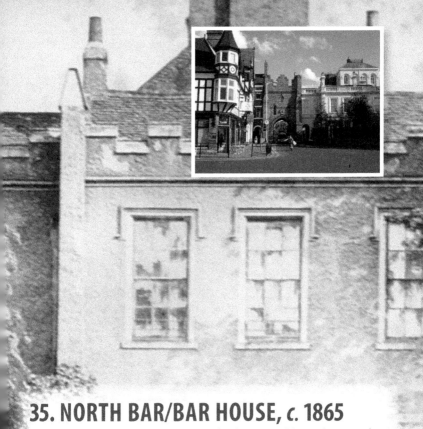

35. NORTH BAR/BAR HOUSE, *c.* 1865

The bar displays the arms of Sir Michael Warton (*d.* 1688) – Beverley MP and owner of Bar House – topped by his crest, a squirrel. The house was remodelled in 1866 when the present balustrade and tower and a second footpath under the bar were added. However, traces of the earlier house are still visible in the pillars of the garden wall. In the twentieth century Bar House was the home of Beverley artist Fred Elwell, son of James.

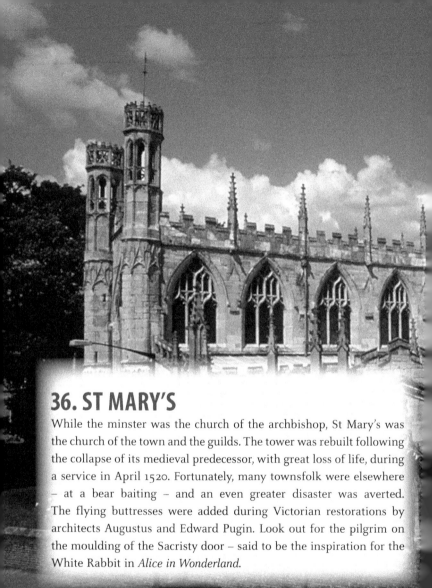

36. ST MARY'S

While the minster was the church of the archbishop, St Mary's was the church of the town and the guilds. The tower was rebuilt following the collapse of its medieval predecessor, with great loss of life, during a service in April 1520. Fortunately, many townsfolk were elsewhere – at a bear baiting – and an even greater disaster was averted. The flying buttresses were added during Victorian restorations by architects Augustus and Edward Pugin. Look out for the pilgrim on the moulding of the Sacristy door – said to be the inspiration for the White Rabbit in *Alice in Wonderland*.

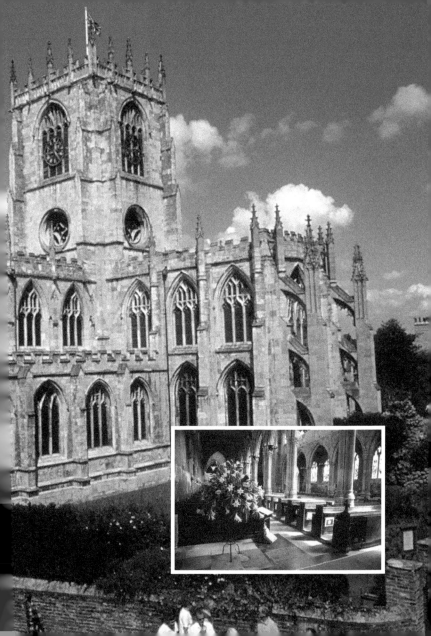

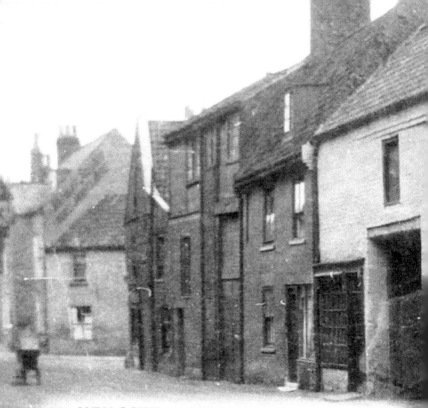

37. HENGATE, *c.* 1920

Known as Nellie's after its last landlady, the timber-framed White Horse was run by members of the Collinson family from 1892 until 1976, when it was sold to Samuel Smith's. The brewery installed a bar, but otherwise left the nineteenth-century, gas-lit interior untouched. The buildings left of the mullion-windowed shop were demolished when the bus station was built and the Manor Road/Norwood junction widened in 1968. Modern traffic patterns put a great deal of pressure on Hengate and its buildings.

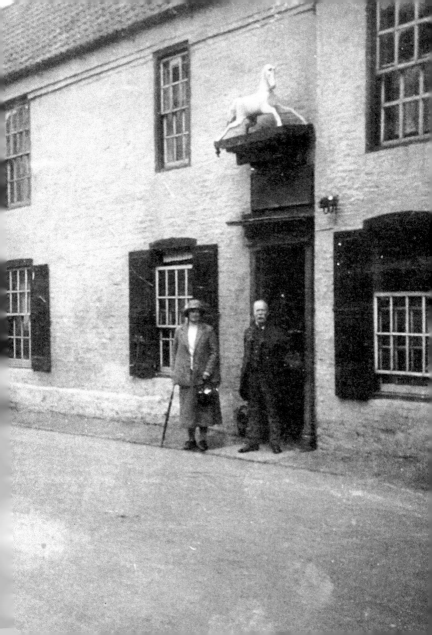

38. NORWOOD, *c.* 1890

Old Porch House was demolished in the mid-1940s. The site was later occupied by the Clock Garage and is now home to Kwikfit. The adjoining cottage (left), with its late Georgian shop front, is now Beverley Music Centre. However, the buildings further left have disappeared, replaced by Majestic Wine Warehouse and Asda. The butcher's shop (far right) was also demolished and a modern replacement built. Once Thomas Musgrave (*c.* 1899–1937), then Healey and Son (1937–2008), it is now J. H. Family Butchers.

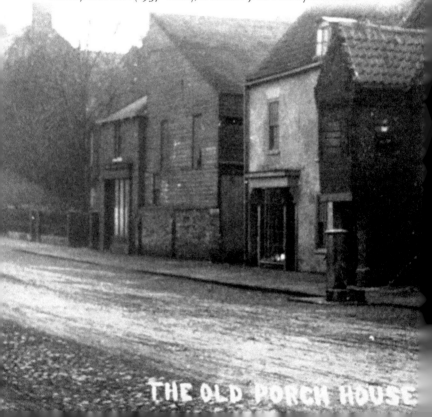

THE OLD PORCH HOUSE

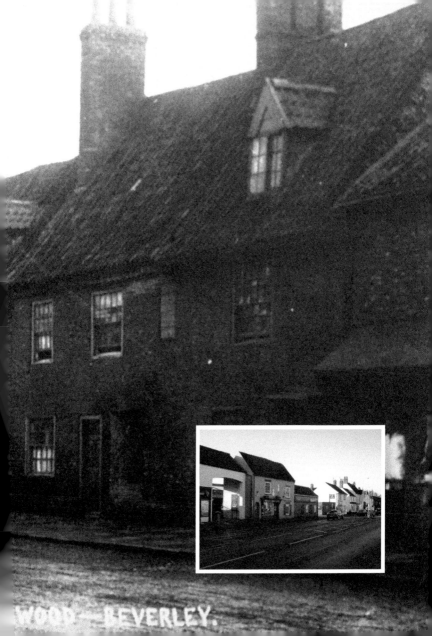

WOOD—BEVERLEY.

39. WALKERGATE/NORWOOD

The cottages behind the cyclist (*inset, c. 1900*) were demolished to provide access to Walkergate School (1906) and were replaced a century later by a residential home. In the background are the Beverley and East Riding Public Rooms, converted in 1935 into the Regal cinema. John Carr's original assembly rooms (1761/62), which fronted onto Norwood, were demolished, but the large hall at the rear, added in 1840–42, was retained. The Regal was demolished in 1999 and replaced by Regal Court – a modern development of shops and apartments.

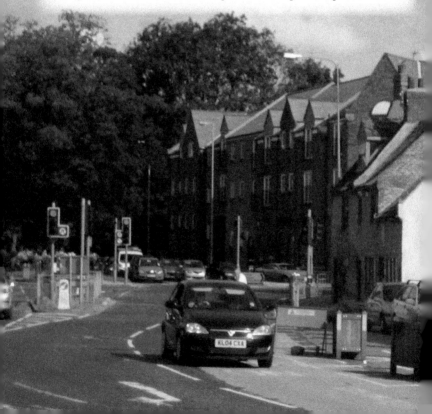

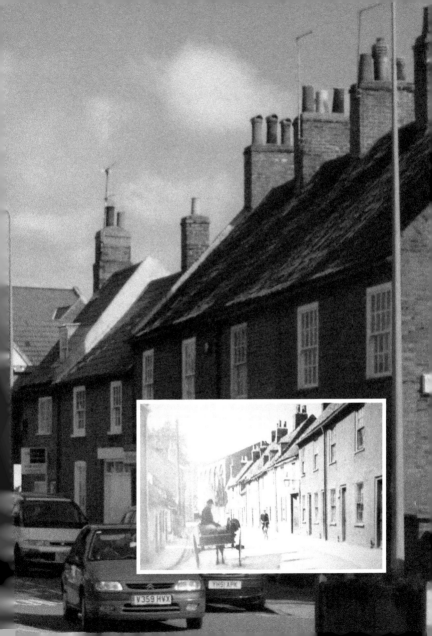

40. LADYGATE, 1930s

In the nineteenth century, brewing and beer dominated this end of Ladygate. No. 6 was the Ladygate Brewery and No. 7 (now Ladygate Interiors) the maltings. Simson's photographers was the brewery tap – the Custom House Vaults – with dram shop at the front and tap room behind. Other pubs included the Globe, the Lion and Lamb at No. 11 and the Freemason's Arms at No. 3 (now part of a private house).

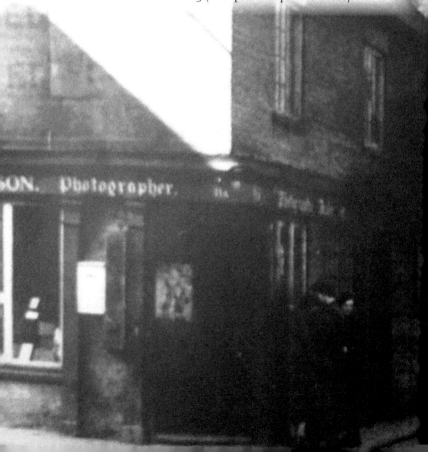

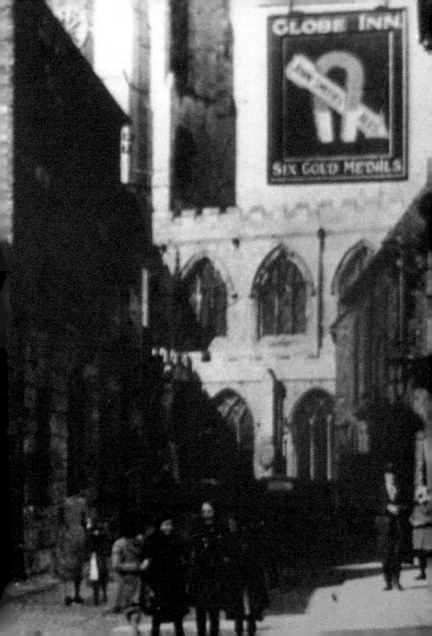

41. LADYGATE, AERIAL VIEW, *c.* 1900

For centuries Ladygate enclosed the Sow Hill end of Saturday Market. The Globe Inn is visible here (*bottom centre*). The adjoining twin-dormered house was also demolished in 1967/68. Now a café, the site remained vacant until the bus station was redeveloped in 1983. Also prominent is Walkergate House (*c.* 1775), once the home of shipowner Henry Samman and now the East Riding Registry Office. Beside Toll Gavel Methodist church is the chimney of the Golden Ball Brewery on Walkergate.

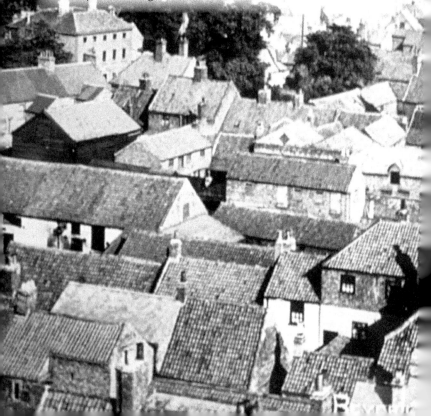

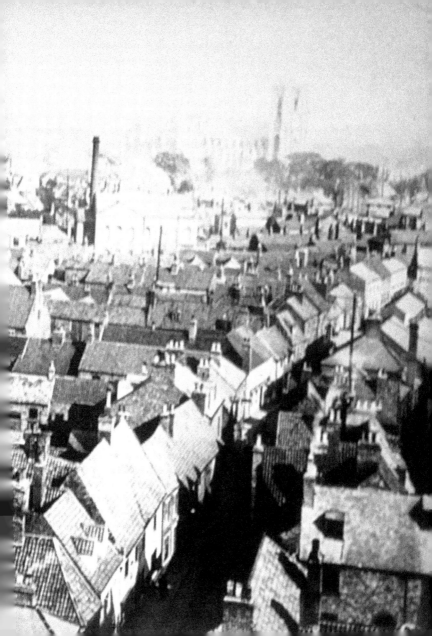

42. KEMP'S CORNER, *c.* 1950

The junction of Lairgate and Saturday Market is still known as Kemp's Corner after John Kemp – printer, newsagent, bookseller, stationer and proprietor of the *Beverley Express* (1856–59). Kemp once occupied this prominent building, demolished in 1955 for road widening. Its slimmer replacement housed the Leeds Permanent Building Society until the Leeds Society merged with the Halifax in 1995 and is now a restaurant. In 1950 Lairgate was still a two-way street and buses waited at the top of Saturday Market.

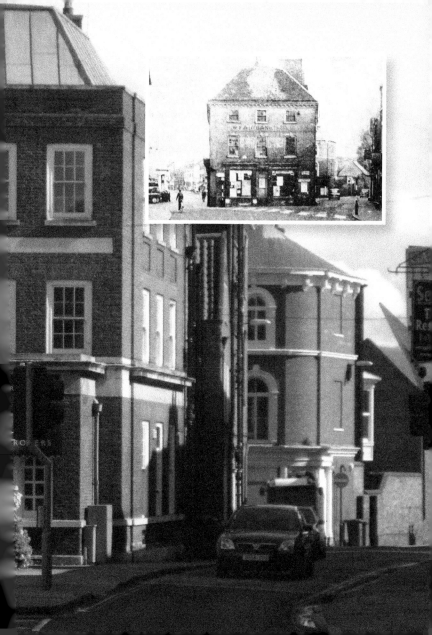

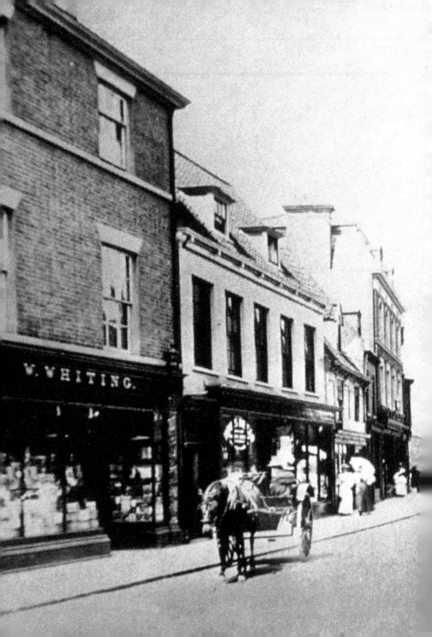

43. NORTH BAR WITHIN, 1890S

Next door to William Whiting's grocery is Field's chemist (now Barbour). A pharmacy operated on this site for over 150 years. The Georgian frontage masks a late medieval interior visible in the timbered north gable and adjoining courtyard and first-floor gallery. Beyond Field's is game, poulty and fish dealer Thomas Trowill (now a clothes shop). On the right is the Beverley (later York Union) Bank, 1861. A bank has operated on this site since 1793 and is now Barclays.

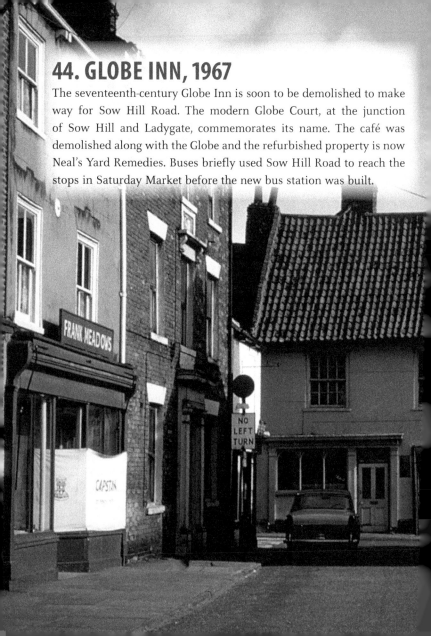

44. GLOBE INN, 1967

The seventeenth-century Globe Inn is soon to be demolished to make way for Sow Hill Road. The modern Globe Court, at the junction of Sow Hill and Ladygate, commemorates its name. The café was demolished along with the Globe and the refurbished property is now Neal's Yard Remedies. Buses briefly used Sow Hill Road to reach the stops in Saturday Market before the new bus station was built.

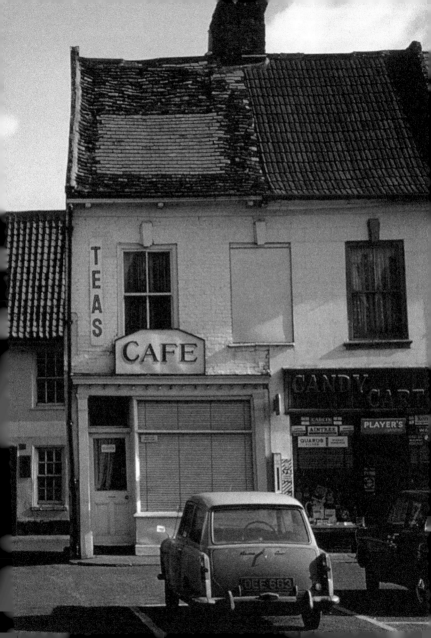